For Sofia

First cdition, 2023

ISBN 978-1-950484-74-4 (paperback)

Published by Spring Cedars
Denver, Colorado
www.springcedars.com

COYOTE
CONVERSATIONS
Photos and Poems From The Field

MARK SURLS

SPRING CEDARS

INTRODUCTION

Winter's white canvas is a duality of treachery and peace, spring has its birds and babies, and summer its flowers and tall grass. But fall is the season every wildlife photographer loves. The leaves, a chance for snow, the elk rut, the glimpse of a coyote augmenting the emotion.

This was a gratifying cycle, however, it was no longer fulfilling. I wanted coyotes in summer's tall grass, coyotes in the color of fall, coyotes courting in winter, and pups in the spring. Everything else became secondary to my journey into the life of America's song dog.

Today, scrolls through social media rule the land, and this is where I shared short notes of coyote scenes then moved on to the next incredible shot. Soon I considered the slower route of coffee table books, but they often remain unopened, stale objects of home decor. I wanted something different. Something that begged to be engaged. Something that was meant to be held, with pictures to be devoured, and poetry nibbled at. My images and words are born from the field. Some are literal, others consider existential connections between our two species. All are meant to make us pause and reflect.

I hope the coyote will gain a new recognition as the magnificent, complex, and social sentient being it is. Thank you for joining me in these coyote conversations.

Alone

A bite in the air.
A light snow falls.
Yesterday, it was enjoyed together.
Fur puffed to keep me warm.
Today, it protects me from pain.
A mate for life was the plan.
Someone could not stop to know.
Now, I sit alone looking out.

Forfeit

Blue to purple.
Purple to orange.
I must get home.
We share this place, but not the time.
I forfeit the sun to you.
An agreement to exist together.

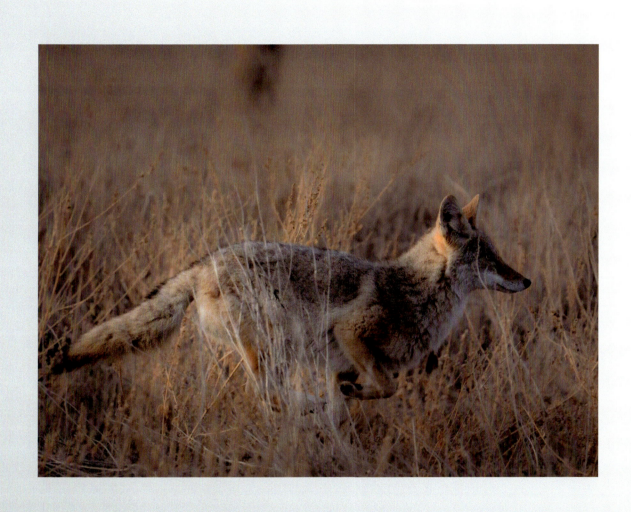

Manifestation

To coexist.
To share time and place.
It takes two, but we are one.
Atoms rearranged, forms changed.
But I cannot be fooled.
Eyes too deep to let me forget.

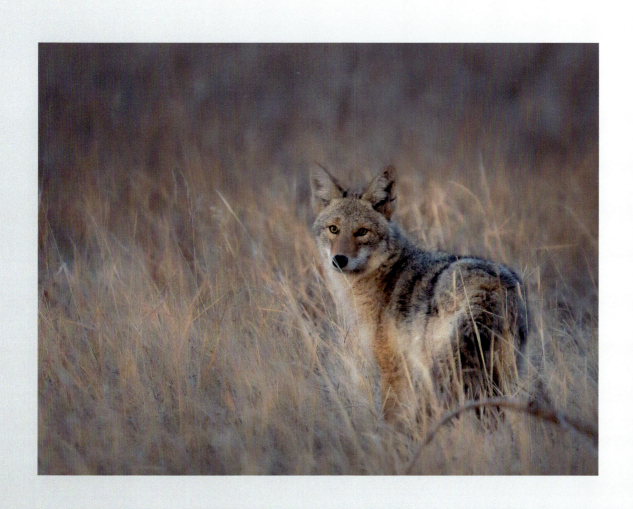

Mousing

To catch a mouse.
Cheese and peanut butter too grotesque.
Use instead, the pianist's ears.
The nose of a sommelier.
The patience of a monk.
The control of a gymnast.
The commitment of a kamikaze.
Such grand design to hunt a mouse.

Thieves

No one tells me to eat my food.
In fact, it's the contrary.
Wait.
Not a feast to be shared.
Must I scream or bite?
Please, haven't you your own?
Wings can surely take you there.

Perseverance

Pity written on my face.
Wonder and resolve on yours.
But how?
What is your secret?
This is the Lamar, three legs should not suffice.
Yet, years pass, and health persists.
A lesson in perseverance not lost.

Highway

The tallgrass prairie is my office.
This path, my highway.
Pride's persuasion can't lead me to difficulty.
So, the coffers must wait.
For now, satiation comes from the sun.

Welcome

What is your infatuation?
You search for us, study us.
You are different from the others.
Though you glimpse us, you seem intent on knowing.
So keen your eye has been, but you missed me.
The whole time, I've been here observing.
But only now do you see me.
You are welcome with us.

Tenacity

It was a mere curiosity.
No harm meant.
Such tenacity.
Bigger worries here than either of us.
Please, stop your charge and all the fuss.
Admiration has been won, no doubt.
So, return to the water and leave me out.

Top Dog

A feast for the taking.
Mustn't relax, though, they still lurk.
In the woods, bellies full.
My brother entombed beneath this beast.
Slain in rage.
A high stakes game, but hunger wins.
Another reminder.
Here, I am not top dog.

How Different

A season that encourages one to dream,
Breeding a simple request, it would seem.
A home, partner, and family,
Is everything I need to live happily.
So, before you are quick to judge me,
Ask yourself, how different are we?

Time Well Spent

Pointed ears, under an otherwise nondescript tree.
An excellent spot for one, but there were three.
The air was frigid, and I sat in the new snow.
How long we stayed together, I do not know.
Long enough to forget about more shots.
Eventually, we separated into our individual plots.

Striking Out

Fifth wheel, odd man out.
We've all been there, no doubt.
But consequences not so high.
One false move, and he'll surely die.
Quick! Roll on your back!
Submission seen, there is no attack.
Winter has been a bother.
Forced from home after a fight with father.
Now, no love is found.
A journey must start, possibilities abound.
Space and time, are his new masters.
Travel fast, my friend, but avoid disasters.
She is there for you to find.
Your past life soon left behind.

Dreamland

Modernity ushers in new ways of life.
Cities flourish, families cut with a knife.
Surrounded by many, I am alone.
I eat and sleep, but there is always a drone.
Calls to friends or foes are left in a void.
Only a siren whines back, sounding annoyed.
I close my eyes to see something more.
There we are together, no longer poor.
Rich with companionship, room to roam.
This dreamland becomes our home.

Moving Day

Mom is home and the pups need food.
She is everything, their whole multitude.
Their trust in her has been a certainty.
And soon, it will move them to safety.
Danger looms, and the time is now.
To leave home, goodbye, ciao.
One by one, she will grasp them in her jaw.
Shuttle them swiftly across the draw.
A better chance to live life fully.
In a world that is tough and unruly.

Meeting Adjourned

Meeting adjourned.
The year's gathering successful.
An ancient assembly for beasts and humans alike.
Called by many names and served for many purposes.
Venues just as diverse.
Frozen lakes, board rooms, valleys, or malls.
Mating dances or dominance displays.
Rituals undeniable.
Be it a bull elk or TikTok star, attention is drawn.
Here, five coyotes captivate surprised guests.
Their rituals finished with no one worse for the wear.

Presence

A pause before an illusion.
I know she will remain.
But my eyes will conspire with the weather.
Intrigue engulfs me as much as the fog her.
Her flirtation with my reality, precious.
Forcing full attention, savoring nuance and grandeur.
Her presence will not be forgotten.

Affirmations and Affection

No guest lists.
No registry.
Affirmations and affection are enough.
The essence of a relationship.
More will be the word after children.
More busy.
More tired.
More life.
For now, enjoying each other is the only obligation.

Old 'Yote

Not a blank stare, but a stare from the blank.
Spring forced into winter by wind and snow.
For an old 'yote who's seen it all.
Unpredictability is to be expected.
His adaptability is matched by few.
His tolerance seen in less.

Escort

Lingering unwanted.
Guests not welcome.
Don't confuse my intentions.
An altercation undesirable.
I am here as your escort.
You see, my babies come first.
So, if you don't object, I'll show you out.

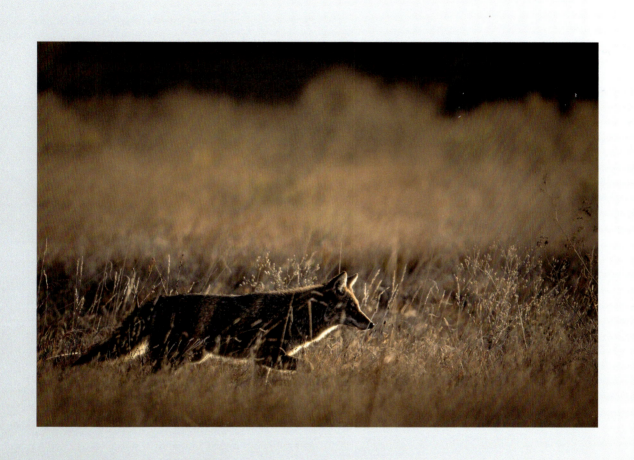

Intertwined

Once, we were young.
Unsure of life.
But time, children, and seasons have all moved on.
Destined to repeat.
What else to do?
The season reminds us with a chill.
Our lives have become our life.
Warmed with our love.
We have become intertwined.

Mission

Attention not broken.
Mission clear.
Tell our story.
Share our book.
Use your heart.
Look again at my eyes.
Know them.
Remember them.
They depend on you.

Transformation

Sitting front row at a wake, for whom, I do not know.

From the attendees, he seems loved.

How much is understood?

What happens next?

Lacking powers of transformation, magpies prove inept.

I wait.

Hours pass.

The deer remains.

Now, it is happening.

A mated pair arrive.

Cautious to begin the ritual.

The male initiates the ceremony.

Transformation begins.

Yesterday, a deer laid frozen.

Today, he walks away a coyote.

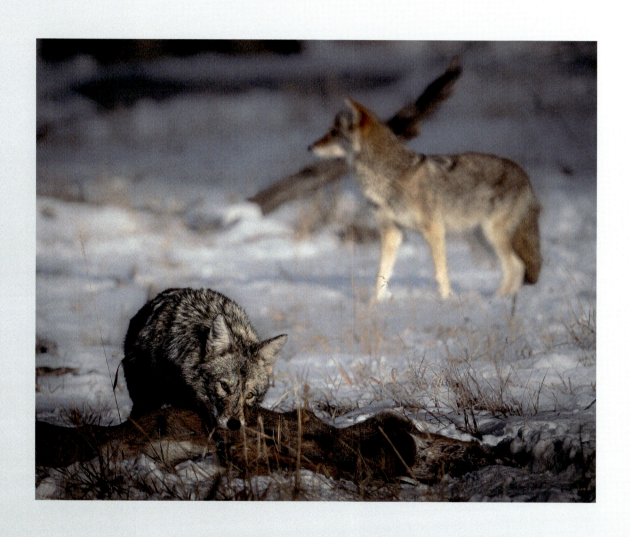

Contest

I lived here and had a good life.
I had a mate, pups even.
I provided for them.
Food, shelter, protection, and play.
I fear for them now.
I cannot be with them anymore.
See, folks came here for some fun.
To have a contest with wildlife, me included.
To kill, to kill me.
Because I was here and alive.
They wanted nothing from me but my life.
I hope my family is okay.
I wish I could tell them why I'm not coming home.
I wish I could tell them to run.

Stretch

Ooohhh...
Long nights or good mornings.
Either one deserves a good stretch.
A chance to pause.
To think about what's next.
A moment for self.
Aaahhh...

Tolerance

What to do when living out of doors?
Hunger does not get buried in the snow.
Modern conveniences nowhere to be found.
You must accept what is presented, a lesson I struggle with.
I need guidance from coyote.
How tolerant coyote is, so accepting of circumstance.
To find peace in wilderness and walls.
So many of us are unable to adapt, yet you thrive.
Persecution has not bred anger, but a wary attention instead.
A recognition of symbiosis with us that is rarely acknowledged.
On with the day.
The snow falls, and coyote is hungry.

Isolation

Privilege is choosing solitude, not being forced into isolation.
Choice changes perspective.
Perspective changes urgency.
Alone and unwelcome.
What lengths would you go, to end your isolation?

Souls' Acknowledgement

We sit together.
Socially distant, of course.
Ribbons of new and old growth.
Avatars obscure.
Peace settles between us.
Eyes lock.
Portals to our depths.
Our souls' acknowledgement complete.

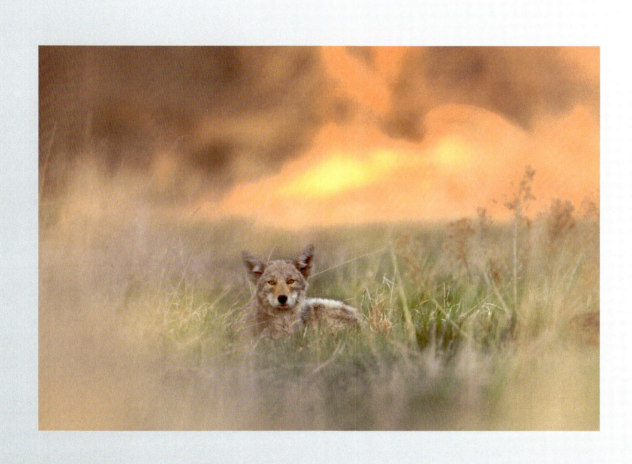

Trapped in Tradition

There is more in common than not.
Nature embraced, traditions continued.
Habits and behavior, not easily learned.
So much is told in plain sight.
Most are ignorant of the language.
Time and commitment to hone a craft.
Admirable and relatable.
And the sheer beauty of the fur, undeniable.
A grand prize indeed.
But it is not mine nor yours.
It is not for sale, stealing, or trapping.
This time, death should come not to the furbearer.
But to this tradition of cruelty.

Matinee

A gaze to the heavens.

Not to ponder existential thoughts.

No, he is built to sing.

A perfect microphone designed into the performer.

Lyrics I don't pretend to understand.

But I hang on every note.

A matinee show full of passion and performance.

An encore so desperately desired.

I Will Help

She frustrates me.
A broken narrative.
A purposely crafted portrayal of beauty.
Ruined.
She was left out of my story.
No fault of her own.
Shutters have clicked many times before.
To find disappointment staring back sickly.
Discarded.
What was I supposed to do with her?
Hide her.
To reveal her, is to acknowledge her.
It acknowledges my lack of compassion.
My lack of involvement.
My unwillingness to help animals I love.
So here is her picture.
This is me saying, I will help.

A Journey of Vulnerability

A book built on compassion.
Though, I struggle with it.
I strive for it to be my baseline.
To set aside differences.
To come together or part ways.
We must strive to do so.
With compassion.
For we all share this place.
We are all granted one chance.
So, come with me.
On this journey.
Of vulnerability and admiration.
May you find the same.

Icons

Two symbols of the American West.
One nearly erased into the tragedy of history.
The other, thriving.
Coyote must relish opportunities to be.
With an old steward of the land.
Bison hides it well.
But under its gargantuan size, admiration lies.
Envy too, for how could their fortunes change so drastically?
For coyote, perhaps, a pause for the fallen king.

Tension

Conditions, rare indeed.
Smoke, fog, rain.
A photographic Triple Crown.
To experience this day, a treat.
To witness the events, unforgettable.
The destination, a slog through green marsh.
More reminiscent of The Okavango than Urban America.
Suddenly, a coyote materializes.
Typical confident saunter turns to running.
Not away, but toward something.
Running with focus, urgency, and purpose.
The feeling is not lost on me.
My feet unable to slow.
But mindful of disturbance.
The scene I am led to, already unfolds.
Tension.
Never has there been a more obvious example.
Solidarity versus maternity.
Triumph or tragedy?
The two cannot be separated.

ABOUT THE AUTHOR

Mark Surls is a second generation photographer with extensive wildlife experience. Featured in local and international photography exhibits and nature publications, he lobbies legislators and speaks to neighbors and strangers, advocating for the animals he loves so dearly. He has worked with the Zambian Department of Fisheries and Nchila Wildlife Reserve as well as thru-hiked the Appalachian Trail. Learn more at www.surlsart.com.